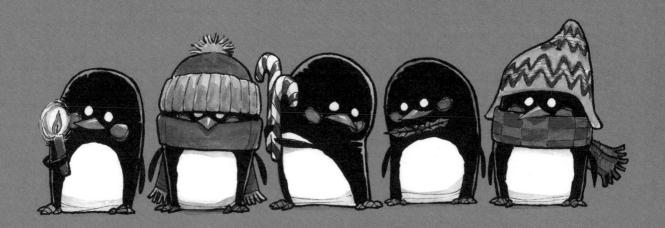

the daily zoo

Goes to PARIS!

Chris Ayers

designstudio PRESS

To the City of Lights,
may you forever shine bright.

ACKNOWLEDGMENTS

While designing this book two months after returning from Paris, my wife asked me what had been my favorite part of the trip. The Eiffel? The Louvre? The wine? The exhibition itself? It was a daunting—perhaps impossible—task to choose just one. After a moment's pause, however, I replied, "The people." Sharing our time with a few familiar faces plus a host of new ones elevated the trip from amazing to something truly special. More so than any of the magnificent sights, it was the people who made the most memorable impressions and the moments that much richer.

Thank you to Galerie owner Daniel Maghen for the opportunity and invitation. To the Galerie staff of Olivier Souillé, Anabelle Araujo, Benoit Guilloux, and Didier Frontini: your hard work and dedication made this exhibition a reality. Laurent Souillé (Olivier's twin and a cop): thank you for giving us your number in case we should find ourselves on the wrong side of dealings with Interpol (luckily we never had reason to use it!). Thanks to co-exhibitor Joe Weatherly and his wife, Jimin, as well as his contingent of loyal fans who traveled thousands of miles to make the show. To all those who came to the opening reception: it was a sincere pleasure to meet you. To the always entertaining Nick Parry-Jones and his lovely partner, Anouk: thanks for the stimulating conversation, book recommendations, and pints of stout. Tremendous gratitude and admiration are bestowed upon the two amazing artists, Angela Smaldone and Cyril Roquelaine, who shared their time and talent in crafting the *Daily Zoo* sculptures for the exhibition. Kathy Sully & Adrienne Nardi: thanks for taking time out of your busy schedules to rendezvous.

Thank you to my family (Mom, Dad, Colleen, and Aaron) for the continued support and making the trip to join us in Paris. A tip of the beret should also go to that mustachioed crepes vendor in Montmartre. Your divine concoctions brought smiles to our lips.

My gratitude is not limited to the people I encountered on the Continent either. Thanks to the Design Studio Press family for yet another fun collaboration, especially Scott Robertson and Tinti Dey for making the quick turnaround on this project possible. To Dr. Gary Schiller and the UCLA team: thanks for keeping me wound and ticking. For the family, friends, and fans that couldn't make it to Paris, please know that your love & support does not go unnoticed. *Merci!*

Last, but certainly furthest from least, to my wife, Thasja:
Mon amour, merci d'être celle que tu es.

Contact info:
Chris Ayers - www.chrisayersdesign.com
Galerie Daniel Maghen - www.danielmaghen.com
Joe Weatherly - www.joeweatherly.com
Cyril Roquelaine - www.roquelaine.com
Angela Smaldone - www.smaldy.blogspot.com

Copy Editors: Nan Ayers, Colleen Ayers, & Thasja Hoffmann
Book Design & Production Layout: Chris Ayers
Photography Credits: Thasja Hoffmann & Chris Ayers
Translation Consultant: Anabelle Araujo

Published by Design Studio Press
8577 Higuera Street
Culver City, CA 90232
http://www.designstudiopress.com
E-mail: info@designstudiopress.com
10 9 8 7 6 5 4 3 2 1

Endpages: Day 2085 - *Penguins' Greetings*
pg. 1: Day 1442 - *Curly Sue*
pg. 5: Day 1906 - *Bothered Bear No. 4*

Printed in China
First Edition, July 2012

Hardcover ISBN 13: 978-1-933492-79-7
Library of Congress Control Number: 2012937719

table des matières

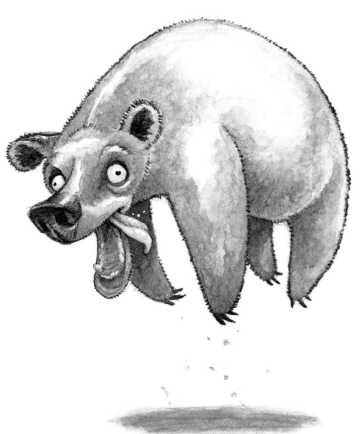

l'introduction

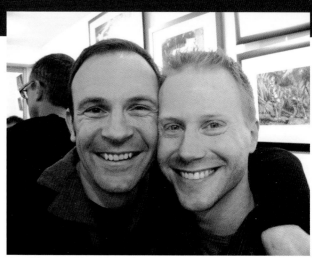

Say "Fromage!"— Olivier Souillé and me at the show's opening.

"Cher Mr. Ayers, I think your work is great. I hope not to disturb you with my mail..."

These words greeted me as I opened an email from a fan in France one day in early January 2009. Little did I know at the time that that message would be the beginning of a correspondence that would eventually blossom into a transatlantic friendship. Three years later that relationship would also lead to my animal artwork being displayed thousands of miles away from my Los Angeles studio on the walls of a Parisian gallery.

But let me back up for a moment.

In 2005, four years prior to that email, I was working as a character designer and concept artist in the Los Angeles film industry. On April Fool's Day my career—and everything else for that matter—was put on hold when a cancer diagnosis of acute myelogenous leukemia slammed its massive fist down on the PAUSE button of life's remote control. Fortunately, though, that pause did not become STOP and a premature EJECT.

After a lengthy and tumultuous period of treatment and physical recovery I devised a personal project to support the continuation of my emotional recovery. By combining two lifelong passions, animals and art, and challenging myself to draw one animal each day for a year, *The Daily Zoo* was born. For those of you who have been following the *Zoo* since its early inception, you'll know that the project proved to be so therapeutic and creatively satisfying that I continued it beyond its initial yearlong timeframe. As I write this, I'm two weeks shy of beginning Year Seven, which will start on Day 2,195. That's a lot of drawings...but what I feel is the bigger accomplishment—and what I'm *most* grateful for—is that it also marks a *lot* of days of being in remission from the leukemia.

Now back to that French guy.

His name turned out to be Olivier Souillé and he is about as passionate and as enthusiastic an art aficionado as I've ever come across. The first volume of *The Daily Zoo* had hit bookshelves only a few months prior to receiving Olivier's introductory message. I was a bit shocked to receive "fan mail" so soon after the book's release but even more shocked to receive mail from the other side of the world! He wrote to tell me how much he had enjoyed the book, not only the drawings but also the story of my cancer journey. He could relate, not exactly on a personal level, but *almost*. Olivier's twin brother, Laurent, had faced cancer about six years before seeing my book.

Over the course of our electronic correspondence, I eventually learned that Olivier worked at an art gallery in Paris. Galerie Daniel Maghen, owned and operated by the esteemed art collector of the same name, is a narrow yet quaint exhibition space beautifully located in the heart of Paris on the south bank of the Seine. From its doorstep you can look to your right and see the bell towers of Notre Dame and then to your left to catch sight of the famous Musée du Louvre, home to such treasures as the *Mona Lisa*, *Venus di Milo*, and works by too many artistic greats even to begin mentioning. (So, to be exhibiting even in the

same *city* as Mona, well…I must admit, not too shabby!) In contrast to the Louvre, however, Galerie Maghen focuses on showing more contemporary artists whose creations fall loosely into the categories of animation art, comic books, graphic novels, and fantasy illustration. Lucky for me, the furry and feathered inhabitants of *The Daily Zoo* fit somewhere into that mix.

Through our correspondence, Olivier proposed the possibility of having an exhibition of my work at the Galerie at some point, and I finally had the chance to meet Olivier and Daniel (as well as Olivier's twin, Laurent) at San Diego's Comic-Con in the summer of 2009. Loose plans for an exhibition were discussed but nothing concrete. When we ran into each other again at Comic-Con the following year, a show was decided upon—actually a dual exhibition with fellow animal artist, the very talented Joe Weatherly—but only a tentative date was set. Finally, yet another year later and again at Comic-Con, Joe and I rendezvoused with the Galerie staff and nailed down most of the exhibition details over a few pints of Guinness. The exhibition was on the calendar for January 2012.

After many late nights and the sacrifice of a significant number of pencils as well as a bit of paint, the art was ready and my wife Thasja and I arrived in Paris a few days before the exhibition opened. What unfolded over the following ten days was pure magic. The hospitality and helpfulness of the Galerie staff could not have been greater. We enjoyed hanging out with co-exhibitor Joe and his lovely wife, Jimin, and had the chance to meet many gracious art enthusiasts at the opening reception, or *vernissage*. What's more, my parents, sister, and brother-in-law were also able to join us, making it a true family vacation. We reveled in exploring the many sights, sounds, smells and *tastes* that the city has to offer. The January rain dampened our clothes but not our spirits. In fact, when it rains in the City of Lights, Paris just grows more beautiful as those lights become twofold when reflected in the wet and glassy streets.

What an unexpected journey it has been, from hearing the doctor utter those fateful words, "You have leukemia," through the arduous process of treatment and recovery, to feeding my soul with the daily drawings, to publication, to meeting fellow artists and cancer survivors from around the world, to this, a chance to share my story and art with yet another audience, and in such an artistically-storied city as Paris.

What an opportunity. What a *thrill*. Or perhaps, after a deep breath of gratitude, I should simply say, *Magnifique!*

March 2012

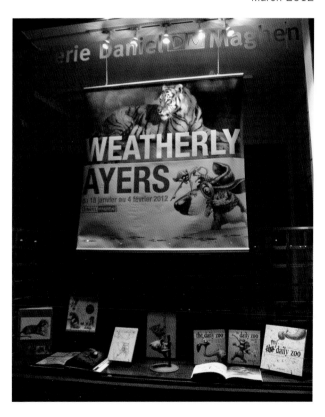

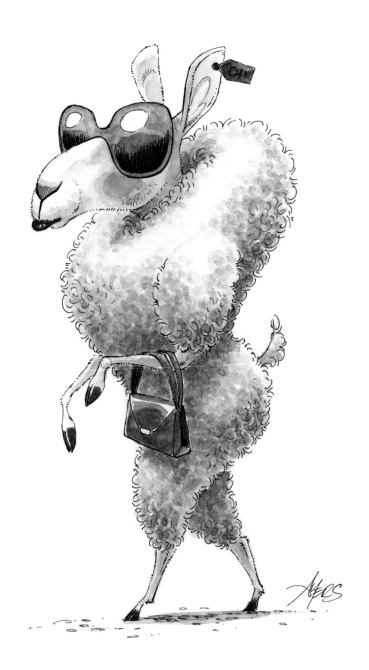

DAY 1939 ▶

Le Chic Sheep

l'exposition

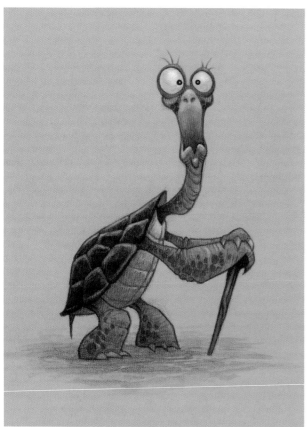

DAY 1987 ◀

Elderly Tortoise

DAY 1831 ▶

Hello, My Pretty!

DAY 2057 ▼

Skunk

The fifty-eight pieces that made up my half of the exhibition were fairly typical of *The Daily Zoo* in that they were created in various artistic styles and with various media. The only rule to which I try to adhere to is to have fun. Play! Explore! *Draw!*

One of the things I strive for in my work as a character designer for the entertainment industry is to create visually appealing combinations of shapes—such as the triangular head and body and the curlicues of the skunk at right. It is my hope that these shapes will form a character that interests the viewer. Of course a character's story, voice, and actions play a large role in whether or not an audience finds that character memorable, but the visual design is also an important ingredient because it speaks volumes about who the character in fact is. Though each drawing is a still image, I try to imbue my characters with a sense of life.

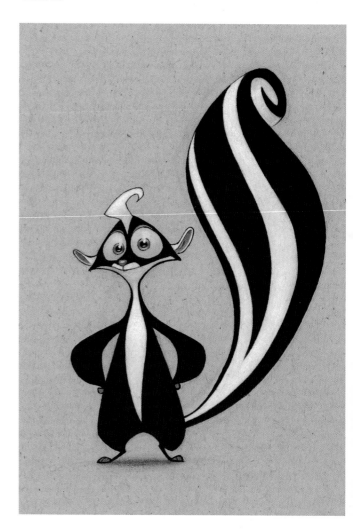

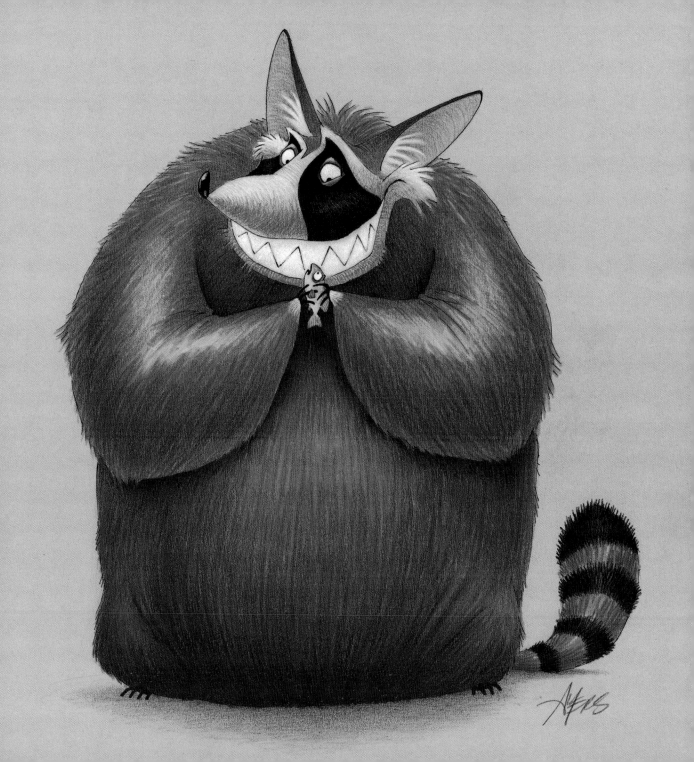

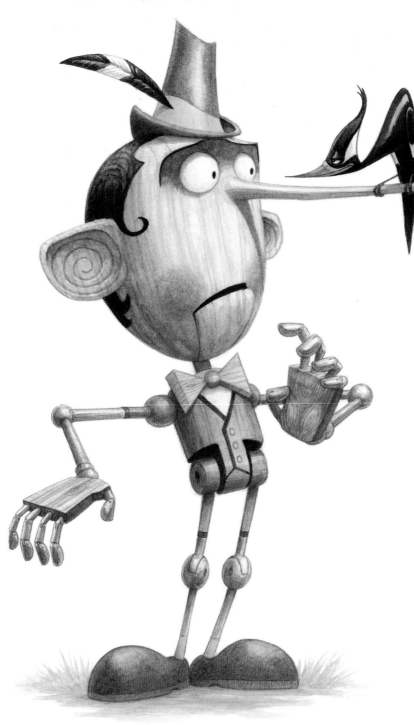

DAY 2036 ◀
Pinocchi-UH-OH!

DAY 2080 ▶
Le Penseur (The Thinker)
Done with sincere apologies to Monsieur Rodin.

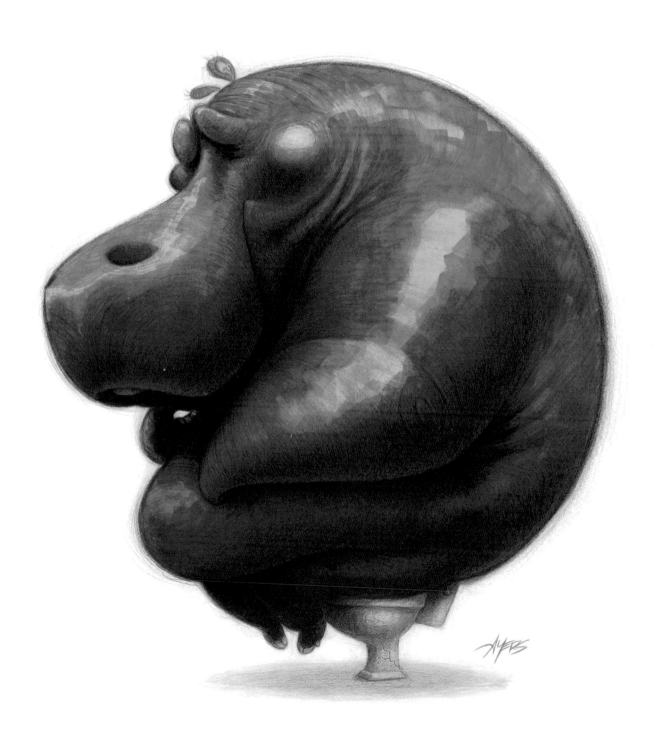

DAY 1849 ◄

Marsh Mellow

The idea for this piece was hatched at Universal Studios Theme Park in Los Angeles. My wife, Thasja, and I were there with friends and just before leaving our friend Sean bought a gigantic Rice Krispie treat. Hefting the massive confection in my hand, I noticed that in the list of ingredients "marshmallow" had been incorrectly spelled "marshmellow." Out loud, I proposed that perhaps that day's *Daily Zoo* could be a chillin' marshmallow. Sean, on the other hand, suggested a mellow marsh inhabitant, which was the direction that I ultimately went. Merci, Sean! Your check is in the mail.

DAY 1949 ▼

Dragon Want to Play!

While drawing this eager dragon, I envisioned the excited nature of a dog waiting to play fetch. They seem to have the same enthusiasm on the hundredth toss as they did on the first one. Though it's not always possible due to time and energy constraints, I try to bring the same sense of enthusiasm when sitting down to do each day's *Daily Zoo* sketch.

DAY 1993 ▲

Professor Parrot

15

Whoops!

This sketch, of an iguana scientist quickly becoming unhinged as he realizes his experiment-gone-wrong may soon be the destruction of all lizard-kind, was done in a medium that was new to me. One of my students had introduced me to a new type of thick—and juicy smooth—colored pencil lead. Tried and true methods and materials can provide a sense of confidence and comfort, but I also enjoy stretching myself by trying the "new."

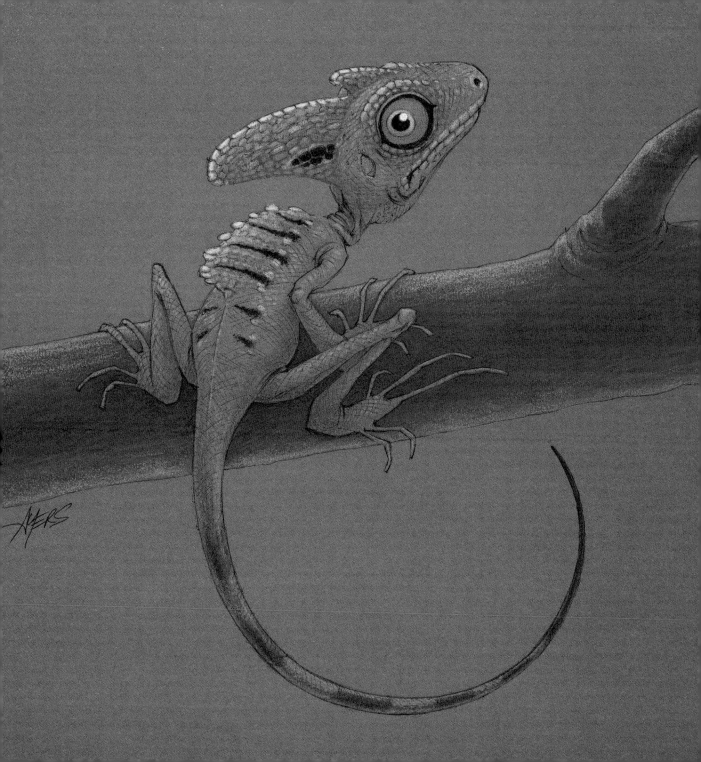

Herlock Hound Is On the Case

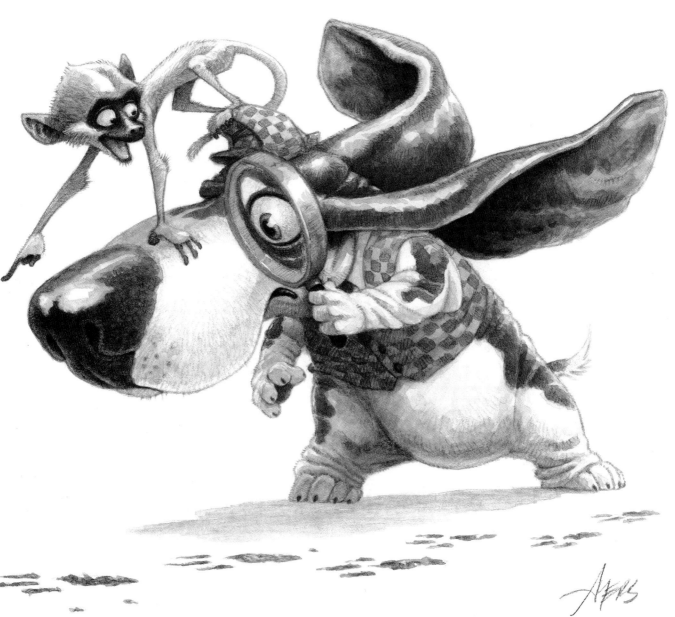

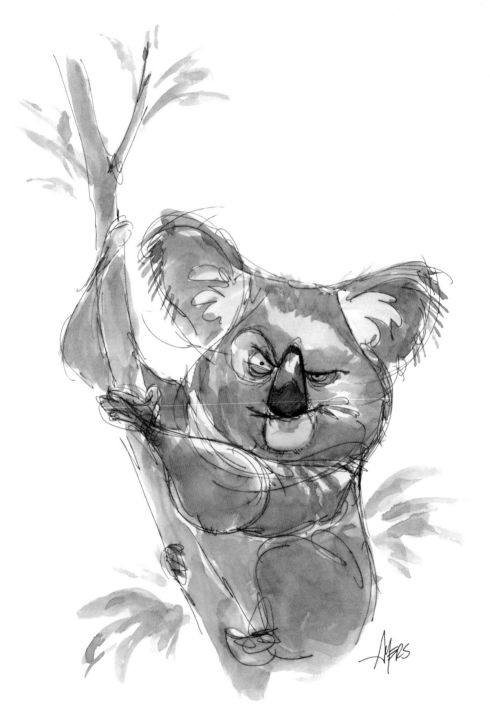

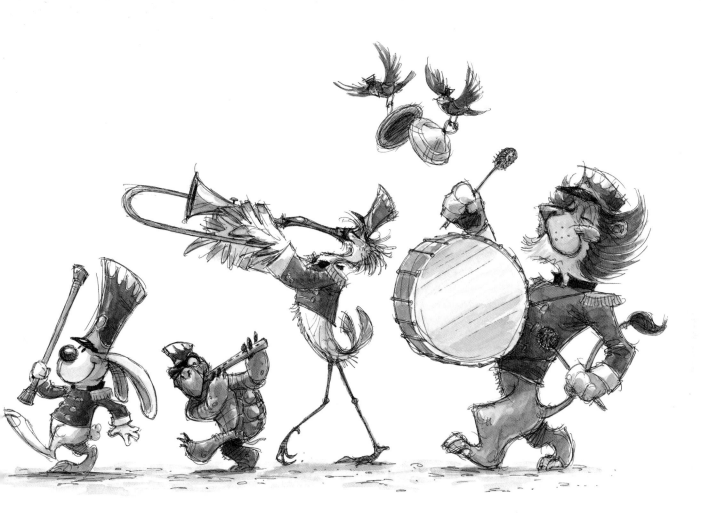

DAY 2032 ▲

Marching Band

Both the koala to the left and the marching band above were done in a looser, quicker style of rendering. I did not lightly sketch with a pencil first as I often do but rather started sketching outright with a pen. It is certainly a less forgiving method and there are actually two specific areas in the marching band illustration where I would have liked to have had a "do-over"…but I'm of course not going to tell you which two they are.

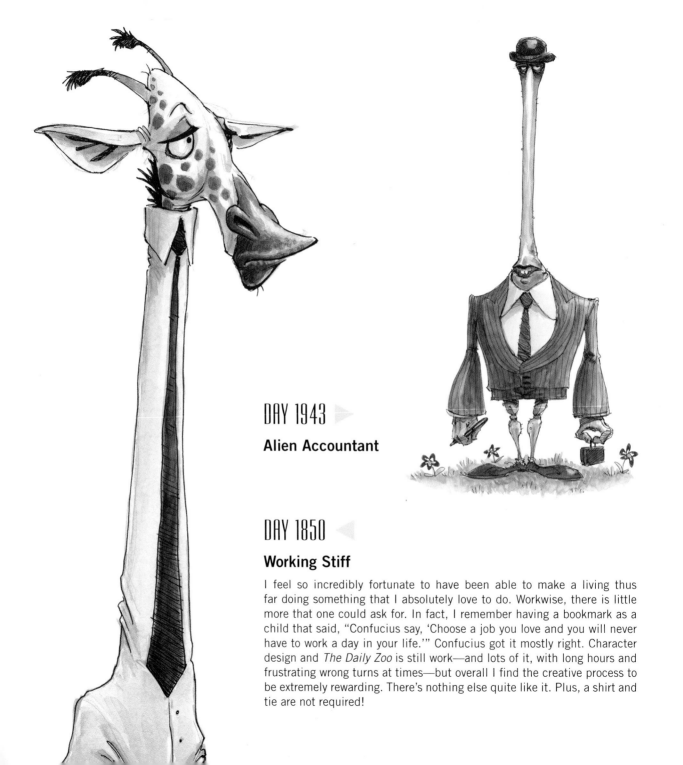

DAY 1943 ▶

Alien Accountant

DAY 1850 ◀

Working Stiff

I feel so incredibly fortunate to have been able to make a living thus far doing something that I absolutely love to do. Workwise, there is little more that one could ask for. In fact, I remember having a bookmark as a child that said, "Confucius say, 'Choose a job you love and you will never have to work a day in your life.'" Confucius got it mostly right. Character design and *The Daily Zoo* is still work—and lots of it, with long hours and frustrating wrong turns at times—but overall I find the creative process to be extremely rewarding. There's nothing else quite like it. Plus, a shirt and tie are not required!

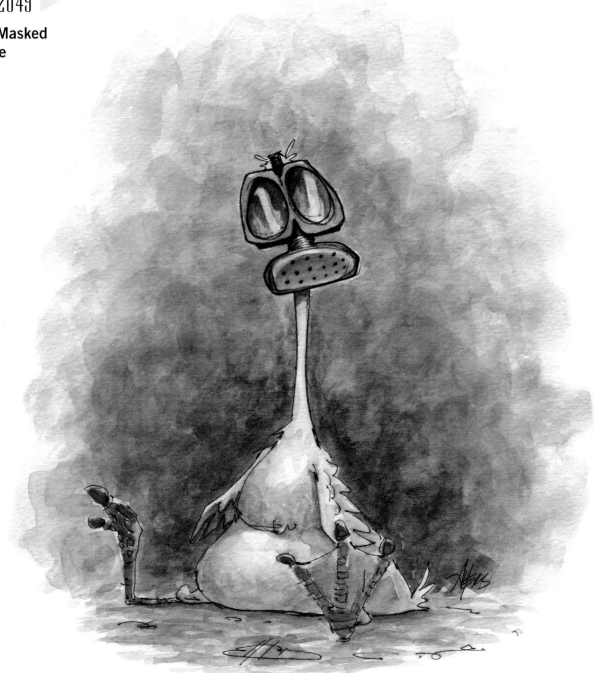

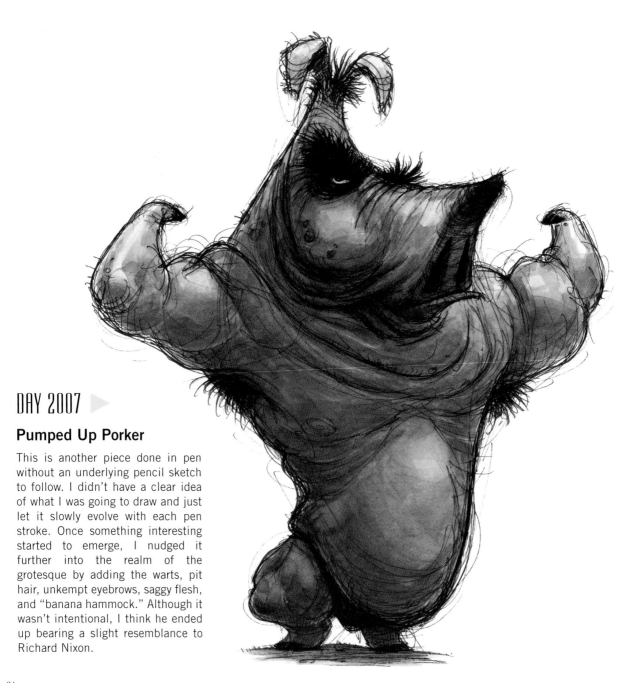

DAY 2007 ▶

Pumped Up Porker

This is another piece done in pen without an underlying pencil sketch to follow. I didn't have a clear idea of what I was going to draw and just let it slowly evolve with each pen stroke. Once something interesting started to emerge, I nudged it further into the realm of the grotesque by adding the warts, pit hair, unkempt eyebrows, saggy flesh, and "banana hammock." Although it wasn't intentional, I think he ended up bearing a slight resemblance to Richard Nixon.

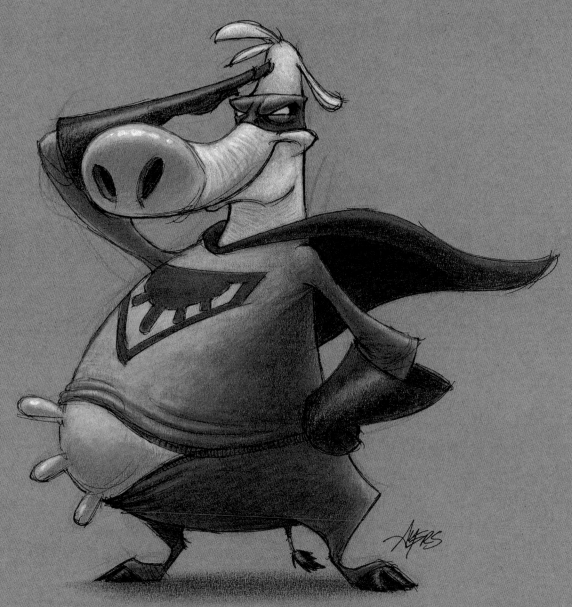

DAY 1578 ▼

Fox

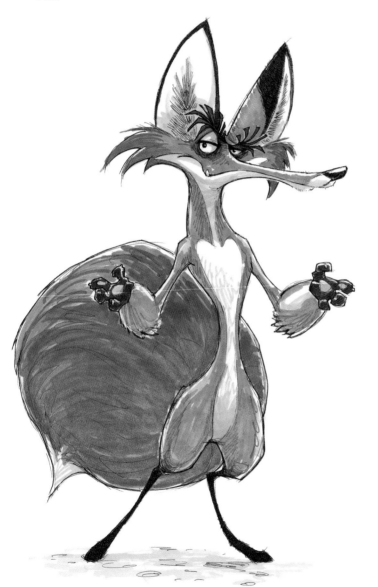

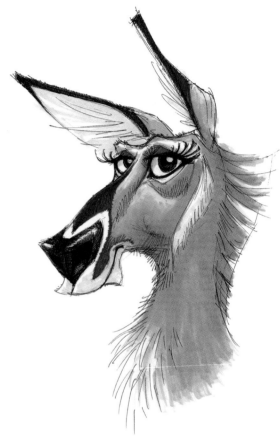

DAY 1908 ▲

Lady Lechwe

Lechwes (pronounced LETCH-ways or LEECH-wees) are a species of aquatic antelope native to parts of Africa. Their long, slender hooves are beneficial to traversing their marshy environment, but make for a more awkward gait on dry land. And speaking of awkward, male lechwes—with practice—urinate on their own shaggy neck beards to declare their social status to the rest of the herd. Talk about eau de *toilette!*

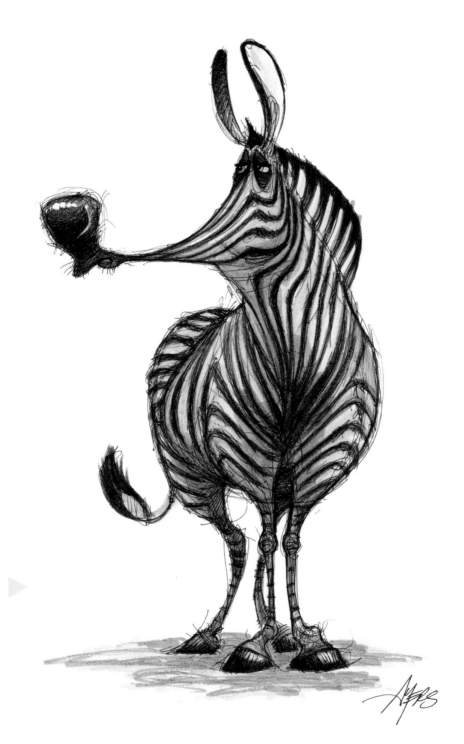

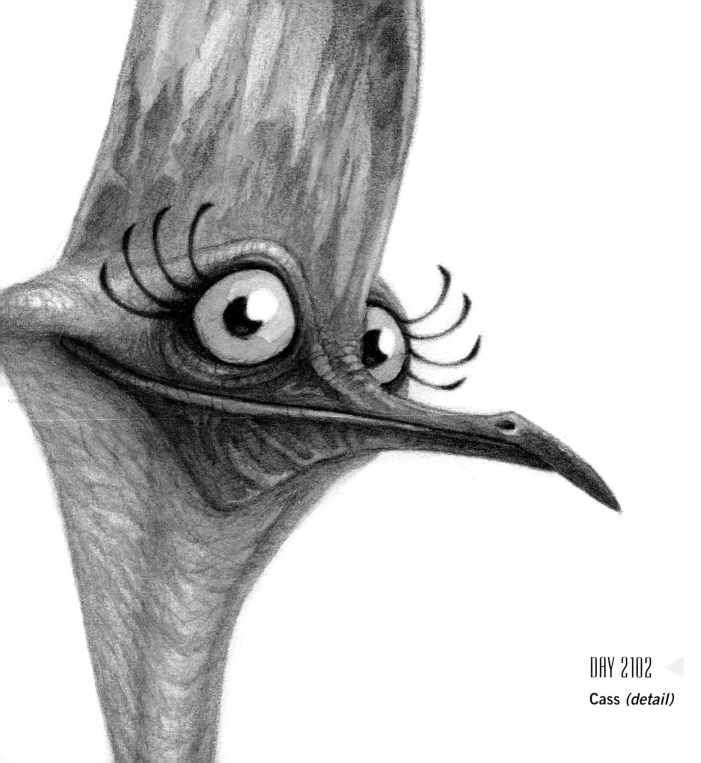

DAY 2102 ◄
Cass *(detail)*

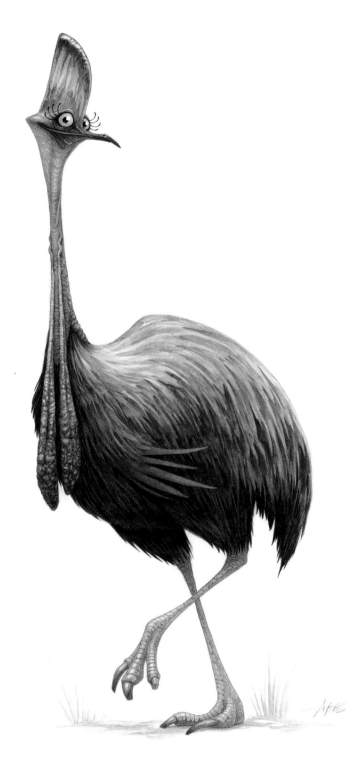

Cass

This cassowary was one of the larger pieces included in the exhibition (18" x 24"). Since *The Daily Zoo* began as a series of sketchbooks, the drawings are typically much smaller. While most of the artwork for the exhibition had been shipped to Paris ahead of time, Cass and a few other pieces were finished later and had to be hand-carried on the plane.

Though Cass is usually a class act, she did make the trip a bit more stressful for my wife and me. Not wanting her or her other drawn companions to be rolled up or potentially damaged in the cargo hold, we wrapped them carefully in tissue paper and bubble wrap, supported them with a rigid board, and put everything in a garment bag.

We had called the airline prior to our trip to discuss options for transporting the art, since it would not fit in an overhead storage bin. Our inquiries were met with gruff inflexibility and two options: either check it in cargo or purchase a First Class ticket (which would allow us to hang it in one of the closets in First Class).

We decided to plead ignorance if it came down to it—always a bit of a risk, especially when dealing with airlines. We didn't mention it at the ticket counter when checking in and were relieved when the package *just barely* eked its way through the security x-ray. Once on the plane, as expected, the artwork was too large to fit into an overhead bin but fortunately the flight staff was much friendlier than the telephone staff and found a safe place in one of those "off-limit" closets in the First Class cabin without batting an eye.

DAY 1904 ▼

Bothered Bear No. 2

My goodness! These big, backwoods bears—burly, bold, and brave bruins that they are—seem to be busy beholding with bleary and baggy eyes a barrage of barbarous baloney, bringing them to the brink of badgered befuddlement! Oh, the joys of alliteration.

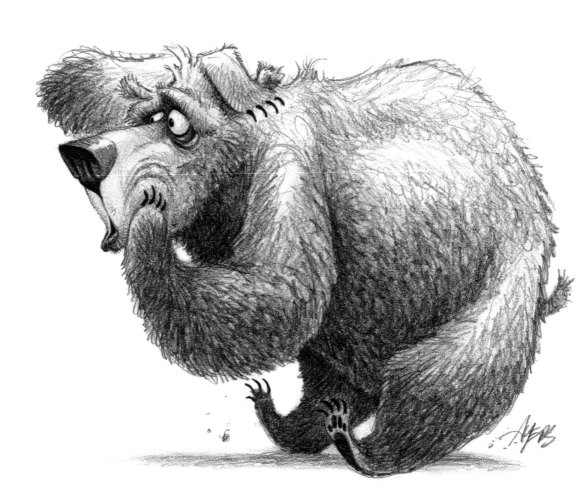

Bothered Bear No. 1

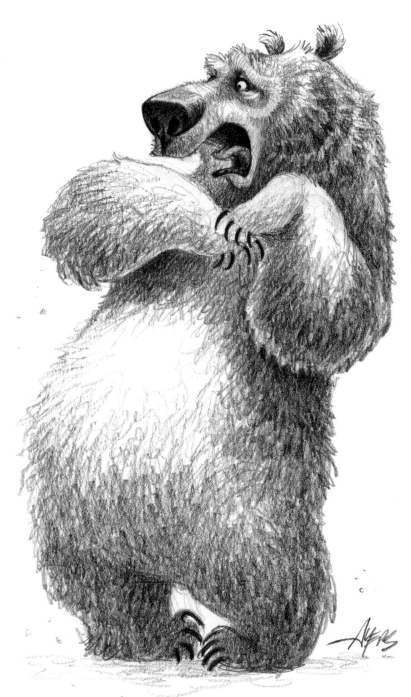

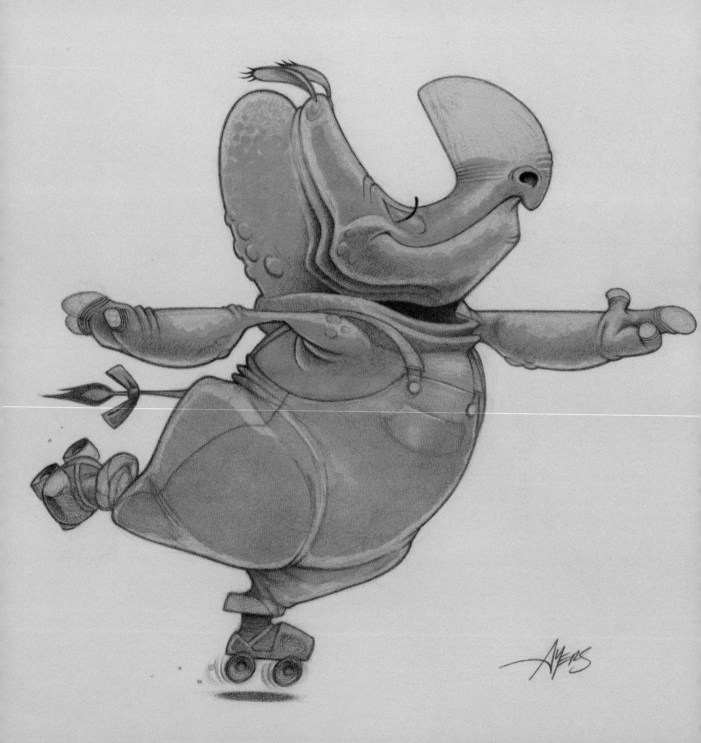

DAY 1760 ◄

Rosie On Skates

Both Rosie and Alistair are characters from a children's book that I have been working on as a side project for some time. It was begun B.C. (before cancer) and thus before *The Daily Zoo*. Though the *Zoo* was started solely as a personal and very intimate project, the decision to publish it has opened up a surprising number of opportunities. I've been privileged to speak at events honoring cancer survivors, draw with sick children in hospitals, lead creativity workshops with artists of all ages, and exhibit my work around the States and now Paris. Finding a balance between my freelance work, *Daily Zoo* activities, and other personal projects (not to mention all of life's *other* activities) has been increasingly challenging, but it is a challenge that I welcome and am grateful to face.

DAY 2072 ▶

Alistair Alligator And His Asparagus

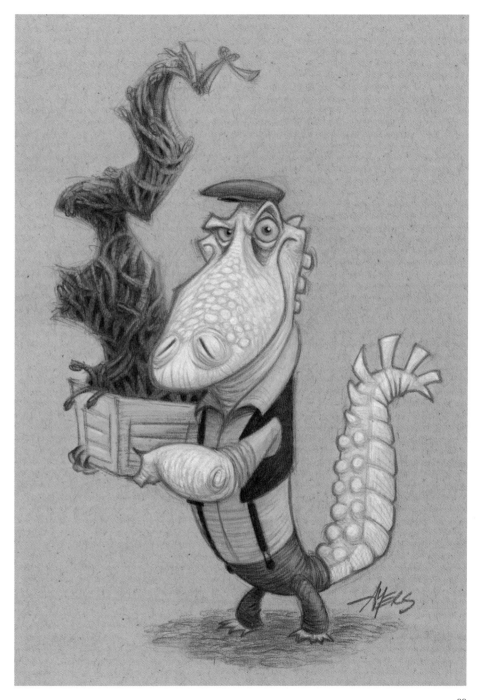

DAY 1614 ▶

Bring It On!

Several fellow cancer survivors have commented that they could relate to this turkey's attitude and the mental toughness that they felt had helped them during their treatments. After the shock of my diagnosis I tried to muster, as best I could in my mentally-shaken and physically-weakened state, the courage and strength to proceed one day at a time. I thought, "OK, well, here we go...I don't really want to...and I'm scared, but...let's go. *Bring it on!*"

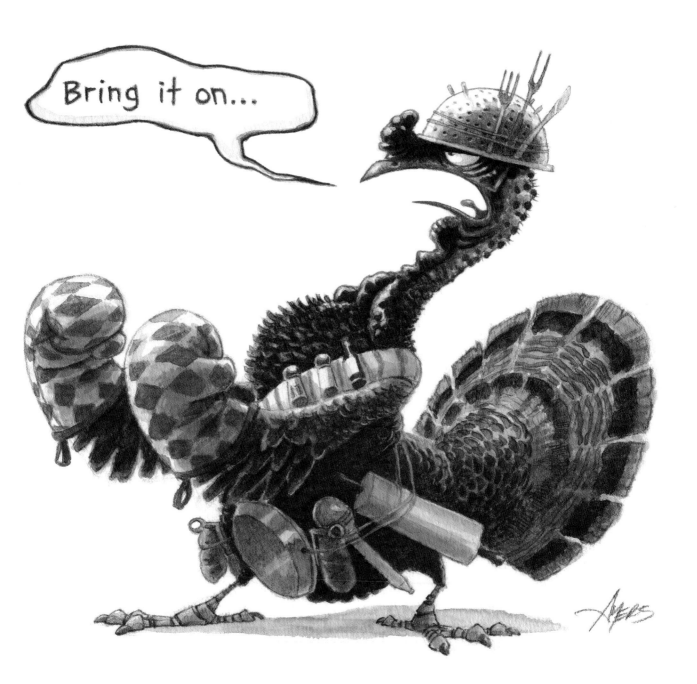

DAY 1739 ▶

A Real Wiener

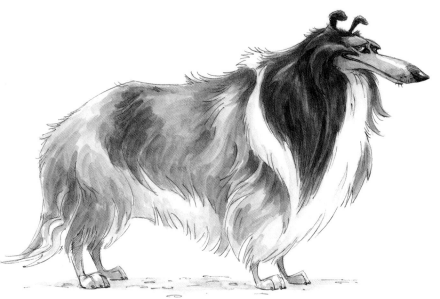

DAY 1930
Collie

DAY 1659
Siamese

DAY 1935
Swirl of Cat

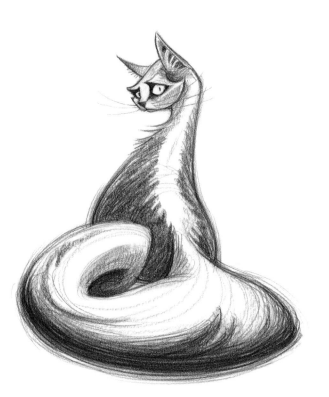

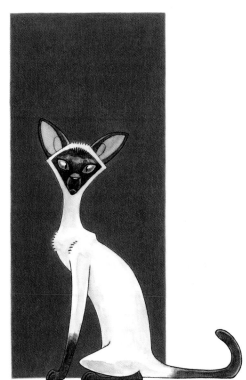

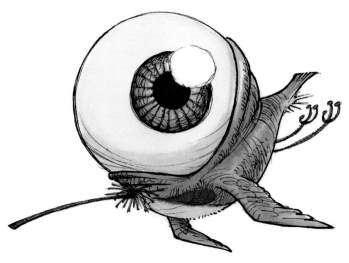

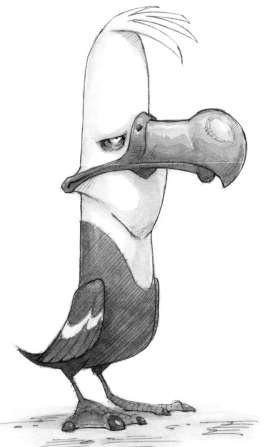

DAY 1770 ◀

Seagull

DAY 1619 ▲

Cycloptic Hummer

This image was not officially a part of the exhibition. The Galerie staff felt he was not on par with the rest of the pieces and so was left off display. However, considering that the little guy made the 5,661-mile flight from Los Angeles to Paris—and on such small wings no less—I figured he deserved to at least make the book!

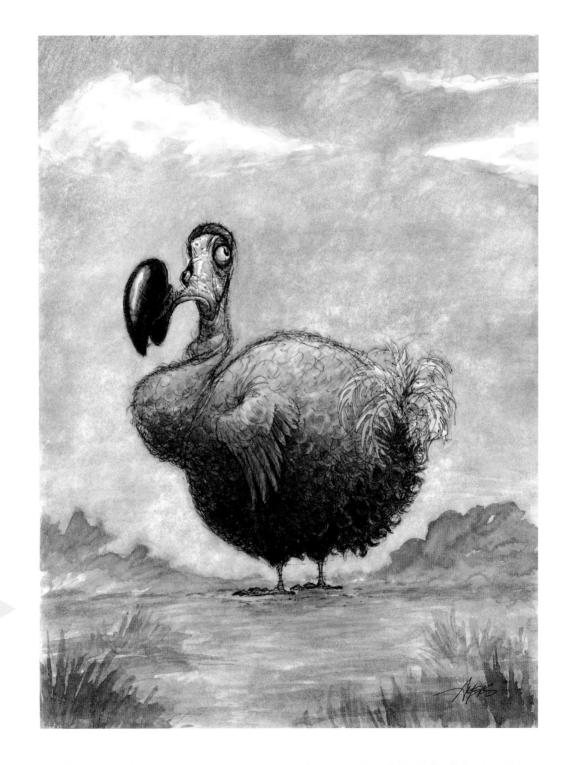

Dodo

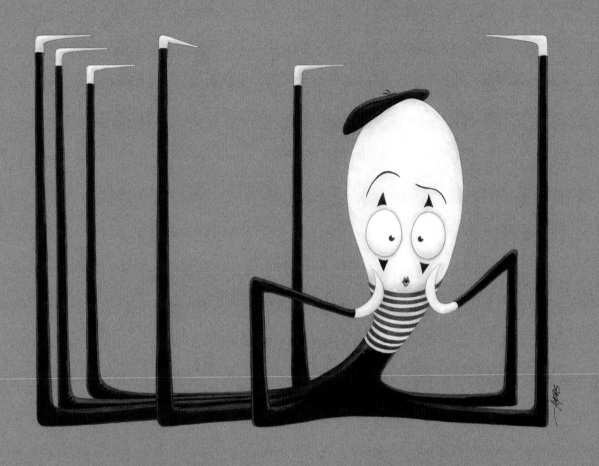

Octomime

The idea for this piece popped into my head shortly after the July 2010
rendezvous with the Galerie staff at San Diego's Comic-Con when the idea of an
exhibition was initially agreed upon. I didn't actually get around to extracting
it from my brain and putting it down on paper, however, until about ten days
before I boarded the plane to Paris in January 2012. It seems mimes often find
themselves trapped within invisible boxes when performing, and I wondered
what that might look like if the mime had eight arms.

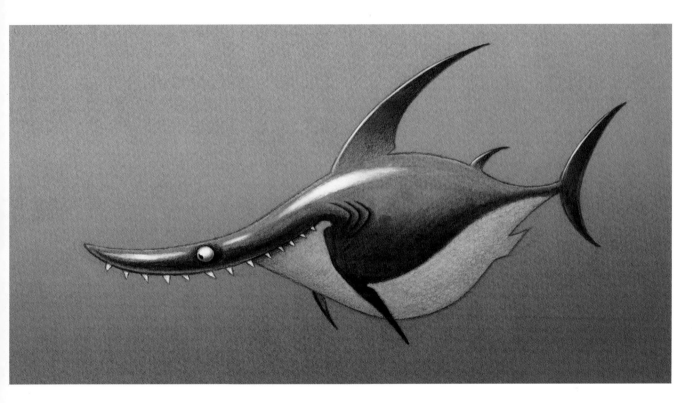

DAY 1947 ▲

Shark

The version of Day 1947 seen here varies slightly from the original sketch shown in the exhibition. I created this version, with its digitally-tweaked background and a few touched-up highlights, for inclusion in the 2011 program of the annual CTN Animation Expo in Burbank, California. For the Paris exhibition, the Galerie was only interested in displaying original pieces—nothing digital or printed—which proved to be a bit of a challenge. I still use a lot of traditional media, but digital software such as Photoshop is often enlisted for final tweaks and adjustments.

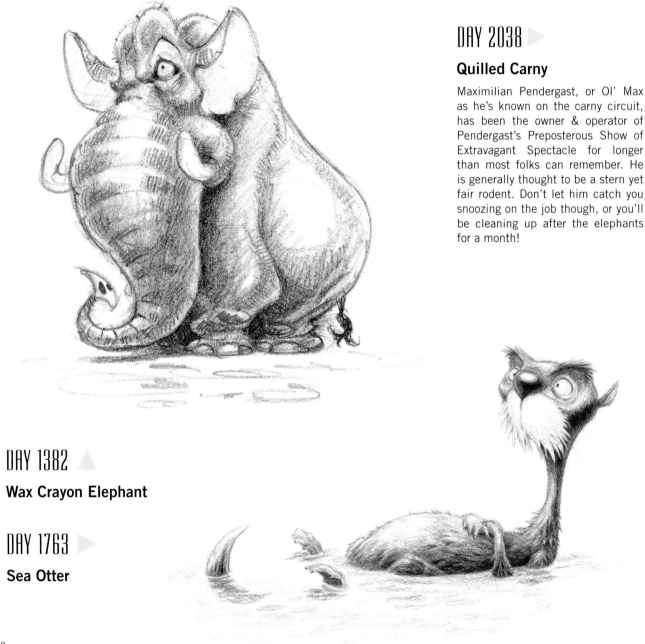

DAY 2038 ▶

Quilled Carny

Maximilian Pendergast, or Ol' Max as he's known on the carny circuit, has been the owner & operator of Pendergast's Preposterous Show of Extravagant Spectacle for longer than most folks can remember. He is generally thought to be a stern yet fair rodent. Don't let him catch you snoozing on the job though, or you'll be cleaning up after the elephants for a month!

DAY 1382 ▲

Wax Crayon Elephant

DAY 1763 ▶

Sea Otter

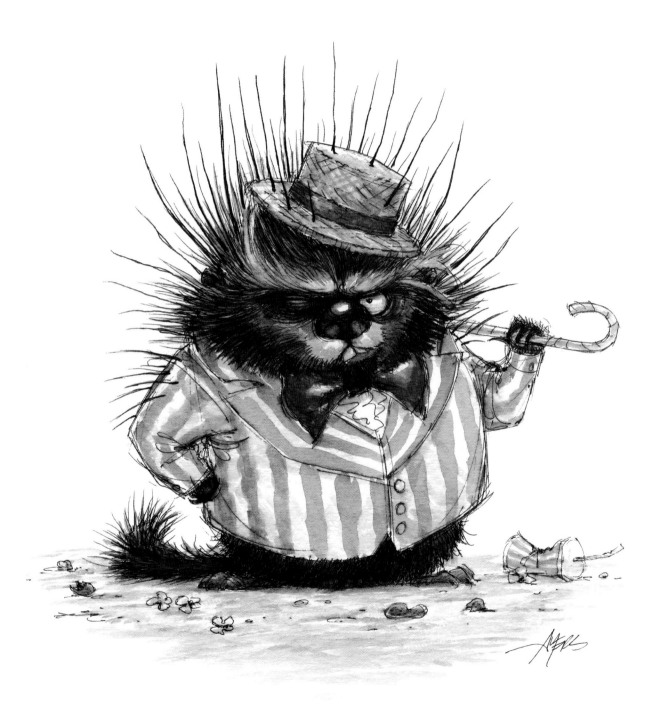

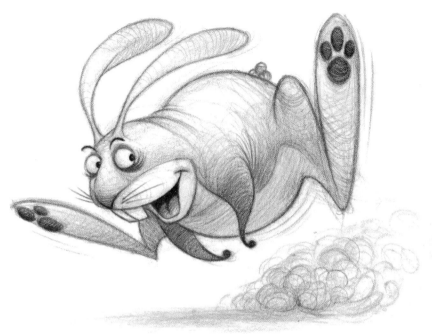

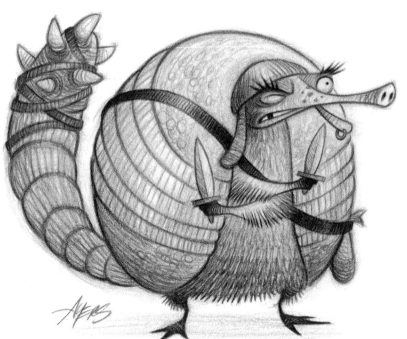

DAY 2012 ▲

Rabbit on the Run!

DAY 1980 ◄

AARGH-madillo Pirate

What's *not* fun about drawing pirates?! *Or* armadillos?!

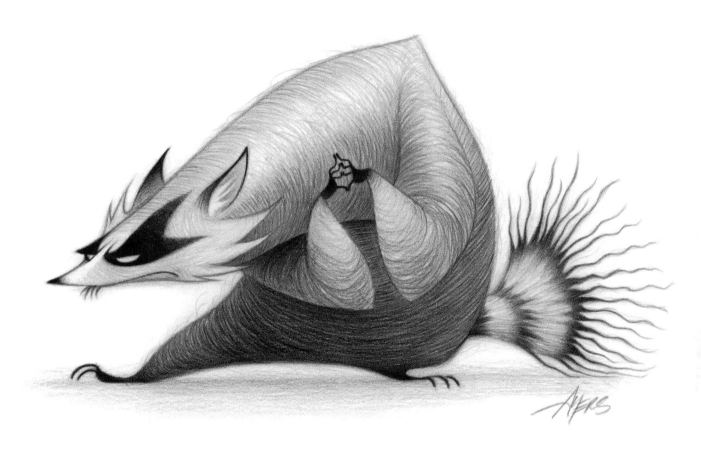

DAY 1968 ▲

Scheming Raccoon

Between this character's shifty stance, scowl, and nefariously-posed fingers and the *Hello My Pretty!* raccoon shown earlier in this book (p. 11) you may get the impression that I think all raccoons are evil, or at least up to no good. That's not the case, though once I did witness a group of them snatch a steaming, fresh-from-the-oven pizza from a patio table, left momentarily unattended, at Yosemite National Park.

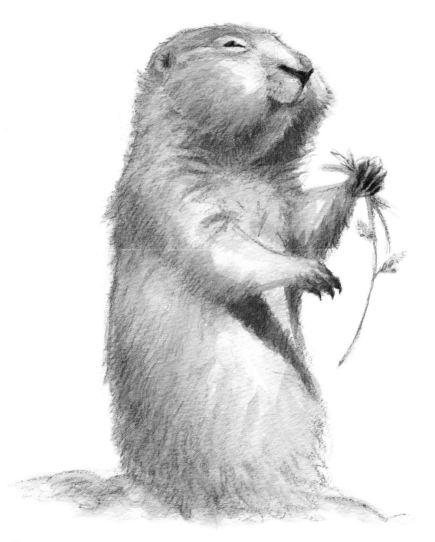

DAY 1775 ◀

Prairie Dog

Anyone who has spent time observing prairie dogs would probably agree that it is very entertaining to watch them scurry about and repeatedly pop their heads out of burrows to take a quick look around. When Thasja and I arrived at Charles de Gaulle Airport we took a train into the city and it became subterranean as we neared the city's center. When we finally disembarked at our stop, weary from a long day of traveling thousands of miles across continents and an ocean, we climbed the stairs out of the Metro station and popped our heads above ground, only to be greeted by the impressive sight of Notre Dame Cathedral. It left no doubt as to where we were. *Bonjour Paris!*

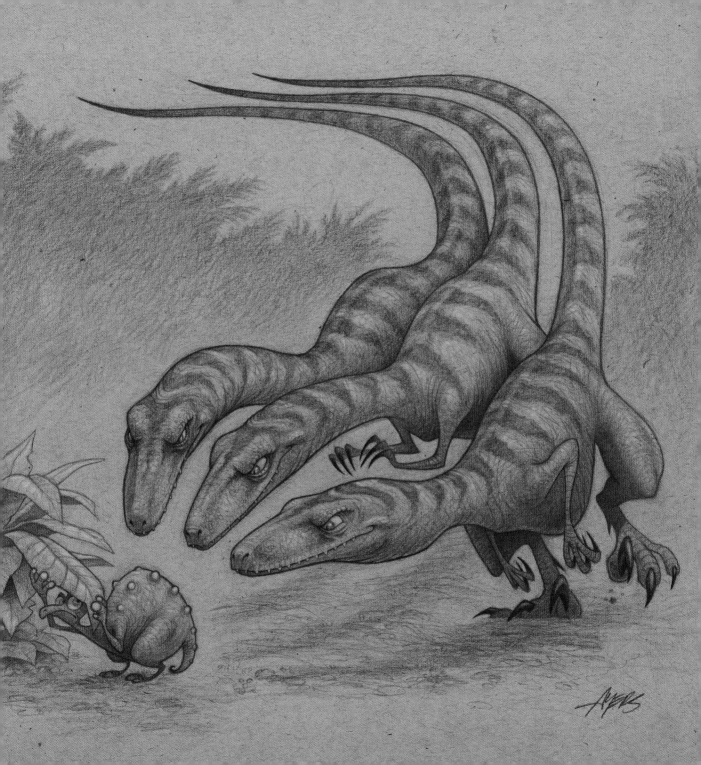

DAY 1788 ▶

Panda

This piece served double-duty by being both a *Daily Zoo* sketch-of-the-day as well as a production drawing for *MY Daily Zoo*, a drawing activity book that was released in the spring of 2011.

DAY 1745 ▲

Frigatebird

Frigatebirds are seabirds in which the males of the species have an intensely red throat sac called a "gular pouch." This pouch inflates as a way to attract females during the breeding season. How's that for a pickup line?

DAY 2015 ▶

Big-Billed Blackbird

I'm not sure how this guy gets *anywhere*.

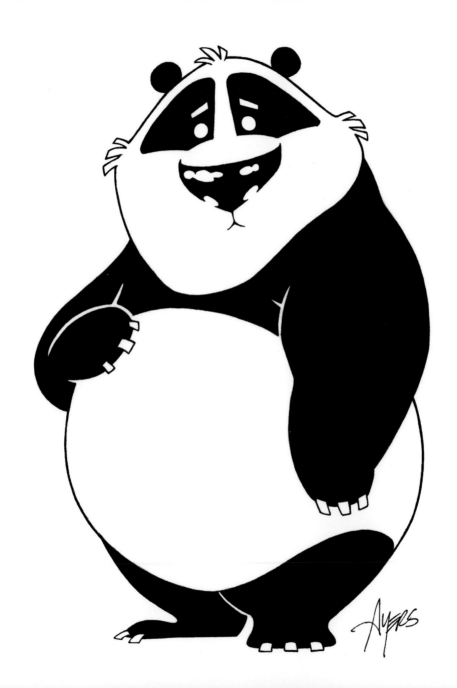

DAY 1933 ▶

Channel Seven's Burt Bouvier

Channel Seven's roving reporter, Burt Bouvier, can always be counted on to provide, if nothing else, an *unexpected* perspective on the day's current events. He was partially inspired by a character I once saw on *Saturday Night Live* with a dash of the late Harry Caray, longtime radio announcer of the Chicago Cubs, thrown in for good measure.

DAY 1916 ▼

Chubbzilla

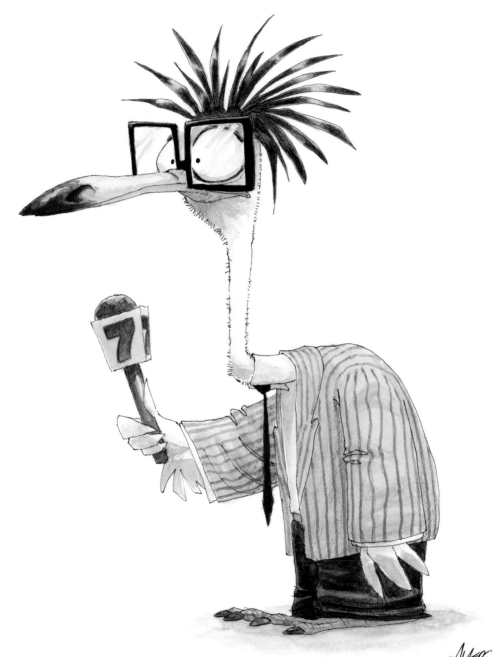

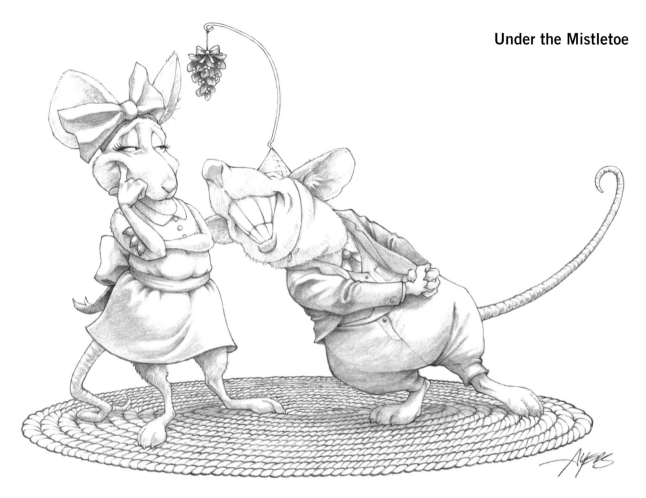

Non-*Daily Zoo* Selections

When discussing plans for the exhibition, the Galerie staff requested a minimum of fifty pieces for the show. Along with having framed pieces on the walls, they also like to have additional works by exhibiting artists on display in large portfolio folders. With over 2,100 *Daily Zoo* drawings I should have had plenty to choose from, right? The "problem" was that most of the drawings are still bound in their original sketchbooks and because of the very personal nature of that project, I haven't quite reached the point where I'm ready to start tearing pages out, especially from the volumes of the earlier years. Plus, *The Daily Zoo* is essentially about the creative process and incorporating my

passions into a daily routine and thus doesn't always result in the more polished pieces that one might expect to find in a professional gallery.

That sent Thasja and me scurrying to the closet to excavate boxes of past drawings to "pad" the number of pieces I was submitting. The sketches on these two pages predate *The Daily Zoo* and were produced for various reasons. The mice above were eventually colored digitally and used as my 2003 holiday card. The walrus and echidna were studies for another personal project and the rhino, well, she was done just for fun!

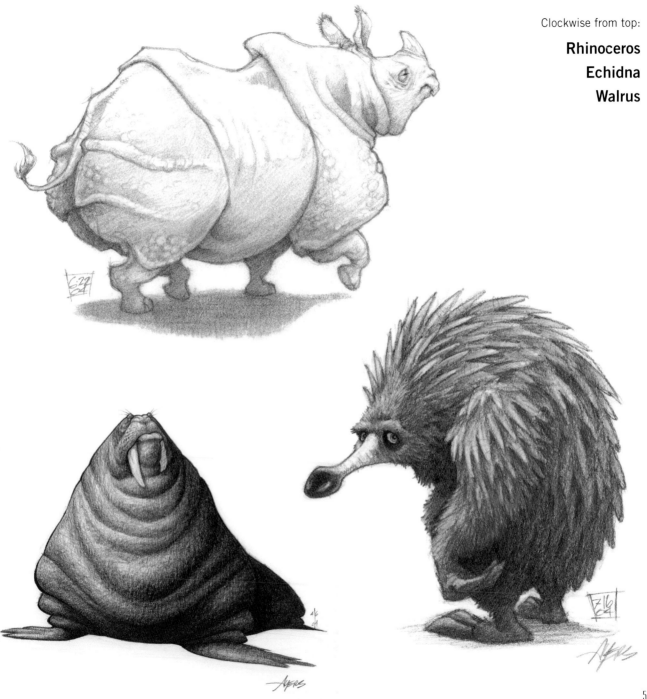

The Daily Zoo in 3D!

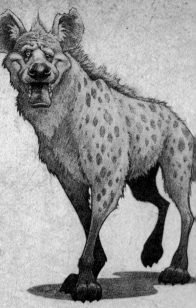

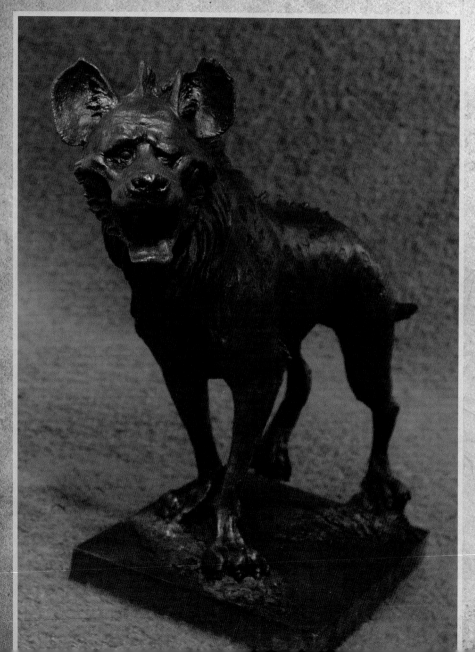

In addition to the two-dimensional pieces in the exhibition, I was fortunate to have the opportunity to collaborate with two very talented artists to bring a pair of *Daily Zoo* characters into the realm of three-dimensional sculpture. Cyril Roquelaine is a French sculptor who contacted me a few years ago to inquire if I might grant him permission to sculpt one of my characters. I met Angela Smaldone, an Italian artist currently living in Paris, at the CTN Animation Expo in California during the fall of 2011, where she too asked about the possibility of sculpting a *Daily Zoo* critter. While being flattered, I was also extremely excited by the prospect of seeing my designs in the round.

Day 032's Hyena,
sculpted by Cyril Roquelaine

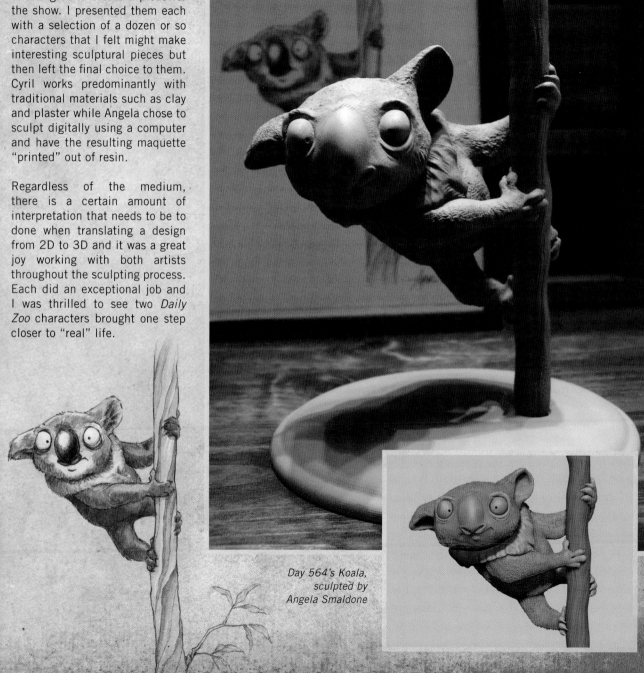

Once the Maghen exhibition was confirmed, I invited both Cyril and Angela to create a piece for the show. I presented them each with a selection of a dozen or so characters that I felt might make interesting sculptural pieces but then left the final choice to them. Cyril works predominantly with traditional materials such as clay and plaster while Angela chose to sculpt digitally using a computer and have the resulting maquette "printed" out of resin.

Regardless of the medium, there is a certain amount of interpretation that needs to be to done when translating a design from 2D to 3D and it was a great joy working with both artists throughout the sculpting process. Each did an exceptional job and I was thrilled to see two *Daily Zoo* characters brought one step closer to "real" life.

Day 564's Koala,
sculpted by
Angela Smaldone

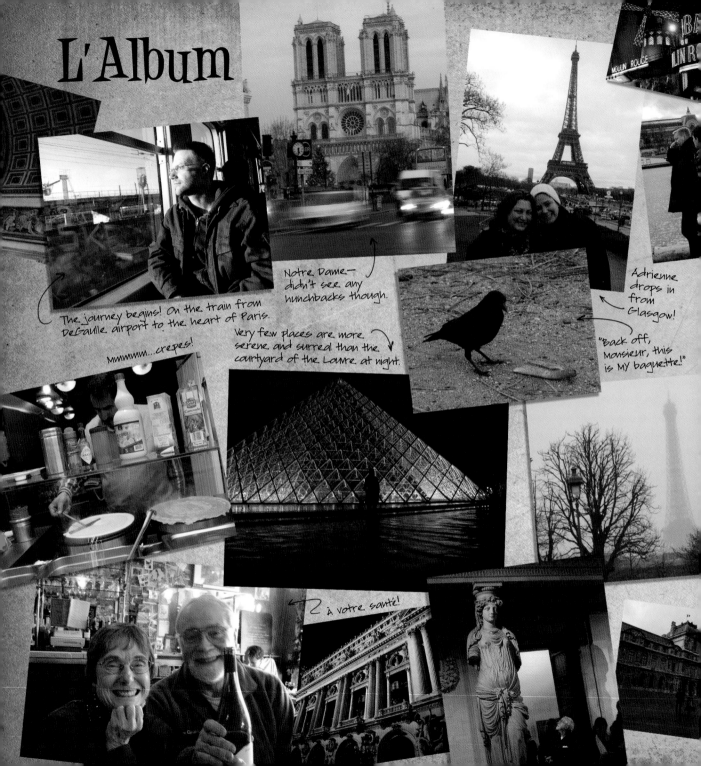

L'Album

The journey begins! On the train from DeGaulle airport to the heart of Paris.

Notre Dame—didn't see any hunchbacks though.

Adrienne drops in from Glasgow!

Mmmmm...crepes!

Very few places are more serene and surreal than the courtyard of the Louvre at night.

"Back off, Monsieur, this is MY baguette!"

à votre santé!

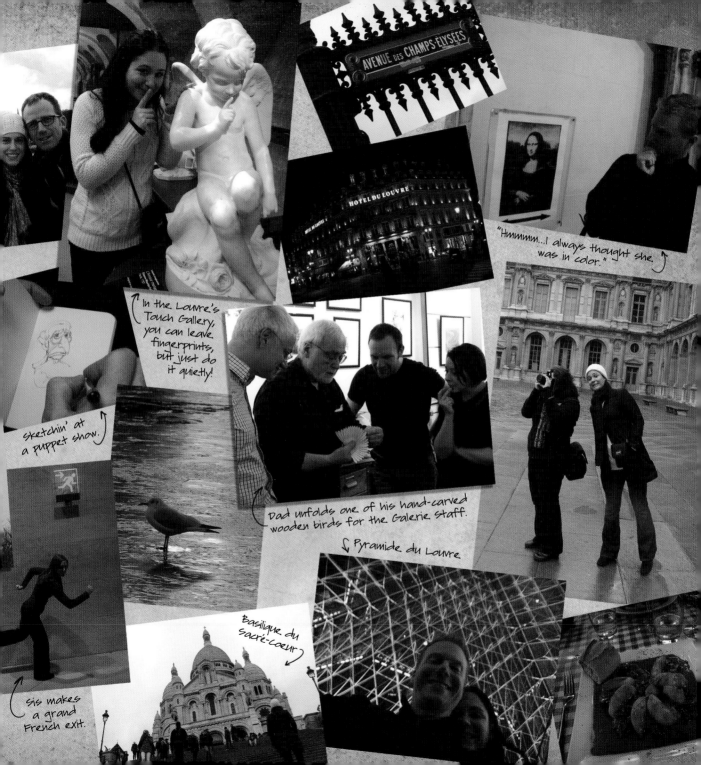

AVENUE DES CHAMPS-ELYSEES

HOTEL DU LOUVRE

"Hmmmm...I always thought she was in color."

In the Louvre's Touch Gallery, you can leave fingerprints, but just do it quietly!

sketchin' at a puppet show.

Dad unfolds one of his hand-carved wooden birds for the Galerie Staff.

Pyramide du Louvre

Basilique du Sacré-coeur

Sis makes a grand French exit.

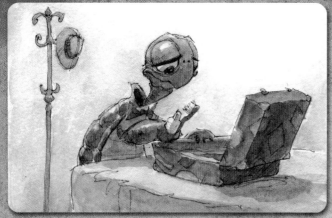

2118

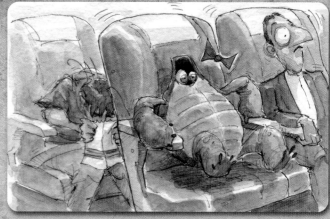

2119

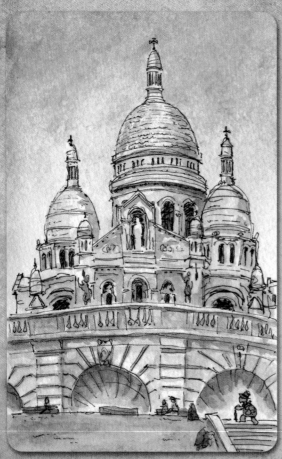

2122

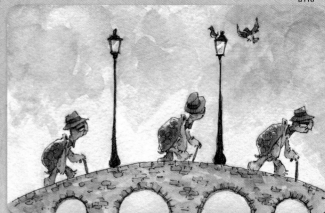

2123

Of course, while in Paris my animal-a-day sketching continued. For some time I had been toying with the notion of doing some sequential art as part of *The Daily Zoo*, having consecutive days tell a narrative. This trip seemed like a good time to give it a try. Thus Mr. Turtle became the lucky recipient of an all-expenses paid Parisian getaway with his experiences echoing my own.

Bags were packed the morning of our **Sunday** departure (Day 2118). Despite fierce turbulence Thasja and I arrived safely in Paris by **Monday** afternoon. A **Tuesday** evening stroll included one of our many walks through the Louvre's courtyard, luminescent with its crystalline pyramids and reflecting pools. **Wednesday** we took in a puppet show in the Luxembourg Gardens.

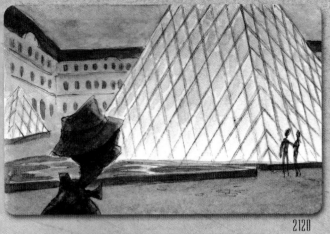

2120

2121

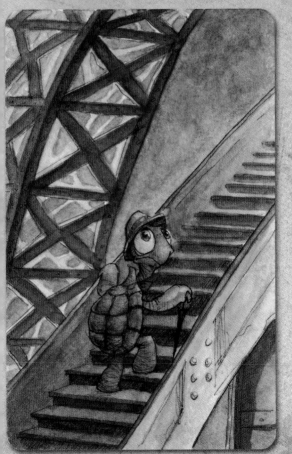

2124

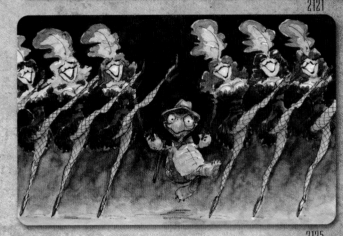

2125

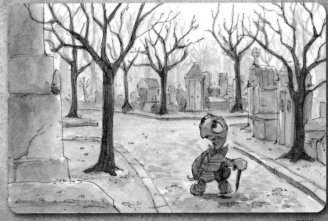

2126

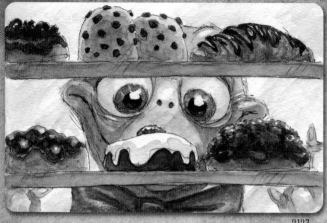

2127

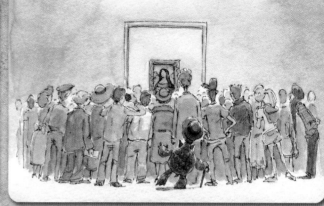

2128

2129

Thursday we hiked up to the beautiful Basilique du Sacré-Cœur. Friday we had a chance to tour Gobelins, the renowned animation school (note the "animated" Mr. Turtle crossing the bridge). Saturday we climbed the Eiffel Tower at dusk when the struts and rivets begin their golden glow for the evening. Sunday we passed by the Moulin Rouge, but didn't go in. It appears, however, that Mr. Turtle did. Monday we explored Paris' largest cemetery and Tuesday we sampled some delectable treats.

Wednesday, our last full day in Paris, was spent at the Louvre where we said Bonjour to Madame Lisa. Thursday it was time to bid adieu to the City of Lights and the Galerie staff and return home. Suitcases were filled with souvenirs, heads were filled with colorful memories, and hearts were filled with gratitude for a truly magnificent adventure.

2130

index

A listing of the 58 pieces in the exhibition, listed chronologically by their date of creation.

Key

Day #, *Title* Date: mm/dd/yy (*Daily Zoo Year*)
medium size: inches (cm) page number

DAY 1820 ▶

Common Snake-Necked Turtle

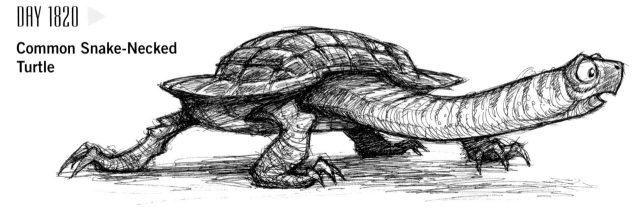

Non-*Daily Zoo* Pieces

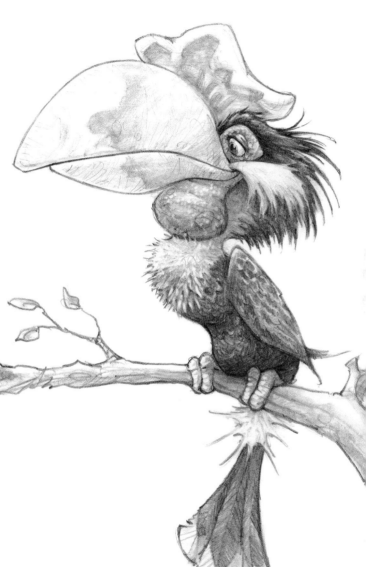

Hornbill

Is your **Daily Zoo** collection complete?

THE DAILY ZOO: VOL. 1
ISBN: 978-1-933492-32-2

THE DAILY ZOO: YEAR 2
ISBN: 978-1-933492-47-6

**MY DAILY ZOO: A DRAWING
ACTIVITY BOOK FOR ALL AGES**
ISBN: 978-1-933492-63-6

And **The Daily Zoo: Year 3**
arrives in DEC 2012!

Please visit
www.ChrisAyersDesign.com
for other Daily Zoo goodies
such as t-shirts, prints,
and notecards.

Please enjoy these other Design Studio Press titles:

To order additional copies of this book, and to view other books we offer,
please visit: **www.designstudiopress.com**

For volume purchases and resale inquiries, please email:
info@designstudiopress.com

Or you can write to:
Design Studio Press
8577 Higuera Street tel 310.836.3116
Culver City, CA 90232 fax 310.836.1136

To be notified of new releases, special discounts, and events, please sign
up for our mailing list on our website, join our Facebook fan page and
follow us on Twitter:

facebook.com/designstudiopress

designstudio |PRESS
designstudiopress.com

twitter.com/DStudioPress

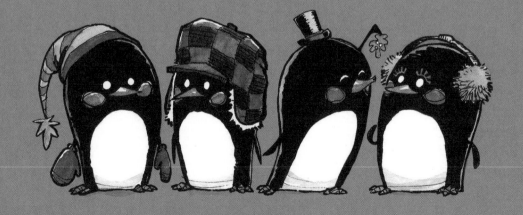